AN ADULT COLORING BOOK BY
AWARD WINNING AUTHOR

Michel Prince

LOVE DOESN'T COLOR INSIDE THE LINES.

SINCE 2012 **MICHEL PRINCE** HAS BEEN MAKING HER READERS CRY, LAUGH AND BELIEVE IN LOVE AGAIN. WITH OVER THIRTY BOOKS IN PRINT YOU CAN NOW GET LOST IN HER COLORING PAGES, ESPECIALLY WHILE LISTENING TO HER AUDIO BOOKS.

All rights reserved. No part of this book may be reproduced in any form, or by any electronic means, including information storage and retrieval systems, without permission in writing from the publisher.

Copyright © 2017 Michel Prince
ISBN: 978-1-387-22675-7
Book Design and Art by Dawné Dominique
Vector Copyrights © VectorStock & DepositPhotos

Published by *Michel Prince*
www.michelprincebooks.com

"YOU WANNA DANCE LIL' GIRL?"
"MORE THAN YOU COULD EVER KNOW."

Not Even In Death, Michel Prince

"I THOUGHT YOU LIKED THAT I WAS BAD."

Redemption of Blood, Michel Prince

"THEY DON'T TEACH YOU LOGIC AT THE SCHOOL YOU GO TO, DO THEY?"
"HAVE YOU TRIED TO REASON WITH A FOUR-YEAR-OLD ON A REGULAR BASIS?"

The Guardian's Heart, Michel Prince

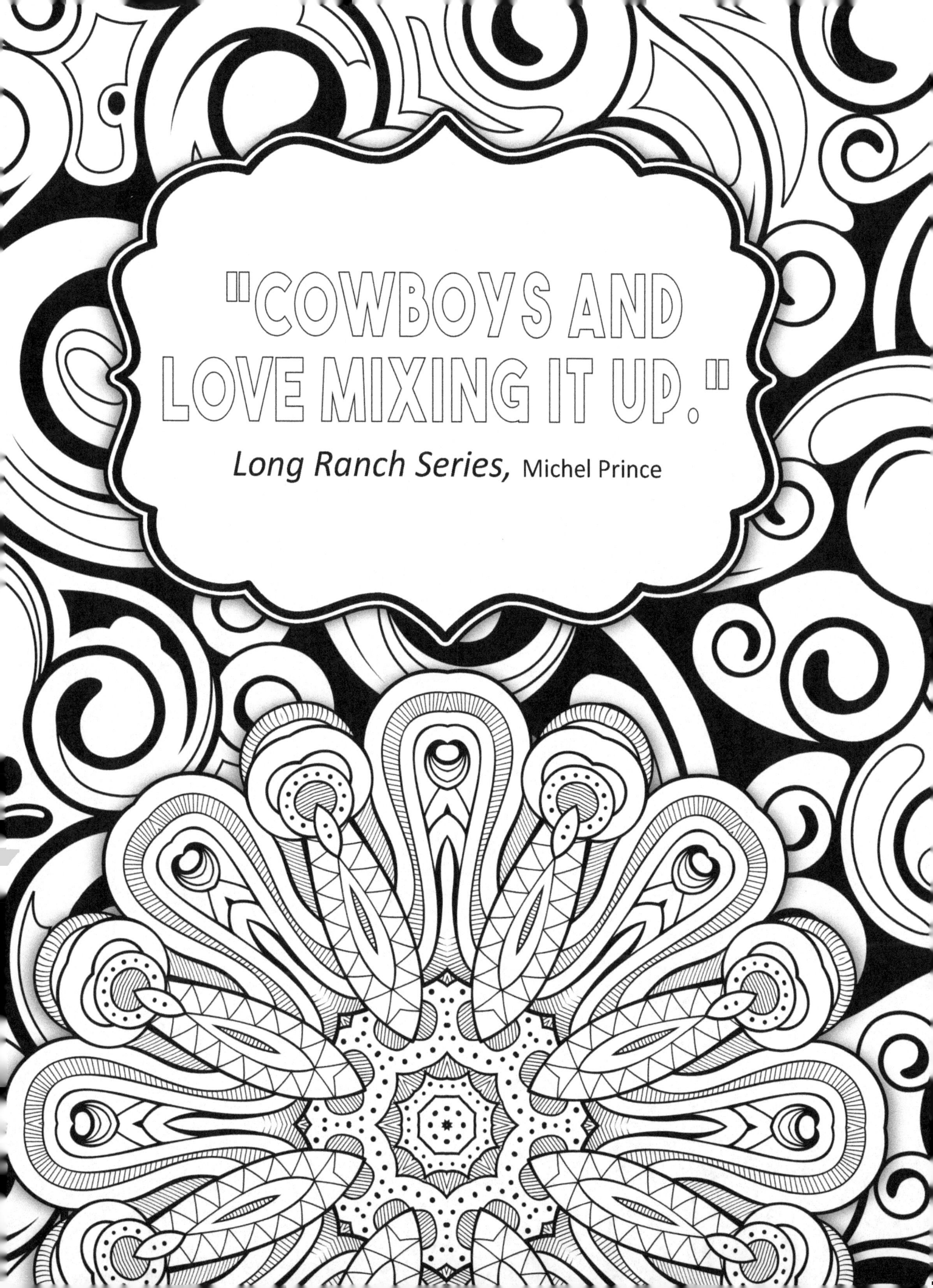

"COWBOYS AND LOVE MIXING IT UP."

Long Ranch Series, Michel Prince

SHE RAN TO THE CITY, BUT HE'LL BRING THE COUNTRY GIRL HOME.

One Last Rodeo, Michel Prince

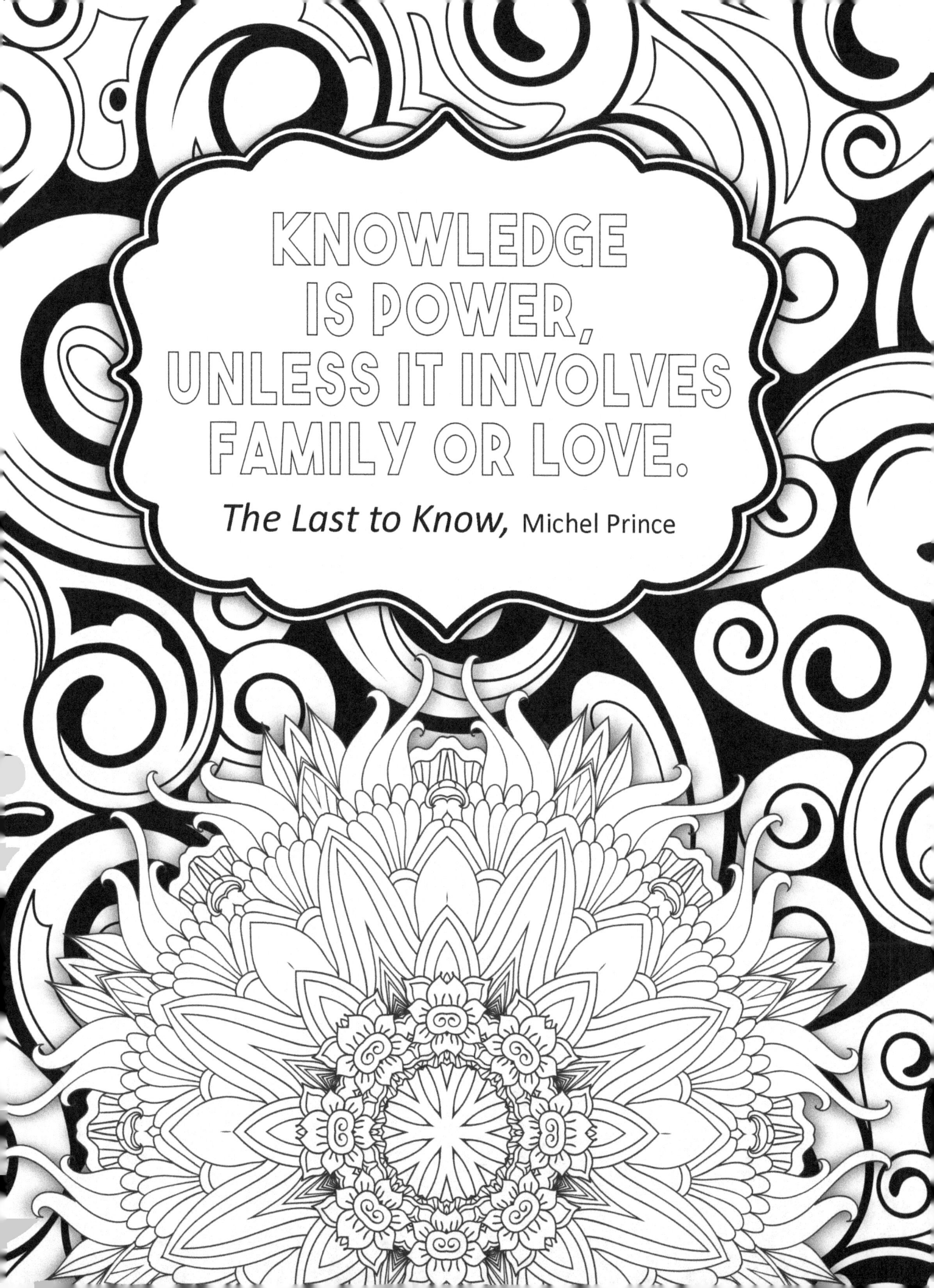

KNOWLEDGE IS POWER, UNLESS IT INVOLVES FAMILY OR LOVE.

The Last to Know, Michel Prince

"BRAND? I THOUGHT WRITERS WERE JUST WRITERS. NOT A COMMODITY."

By the Light of a Blizzard, Michel Prince

COMING SOON
Roadkill

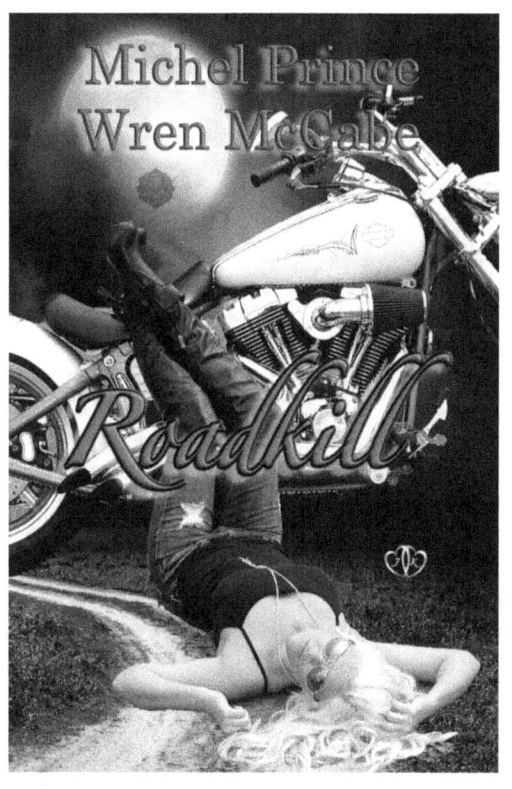

Book one of *Montana Steel MC*

Josh 'Red' Luke, Montana Steel MC Nomad, wants to go home. It doesn't have anything to do with running from something as much as the need to find his place in the world. As a former Army medic, he used his GI bill to become a skilled surgeon, which fills his necessity to help. Together with the training from the military to never leave a man behind, and his soul feels almost whole.

The woman struggles to find her own name and the reason for being brutally beaten and left for dead. However, the memories come in hard, harsh bursts and the struggles to figure who she was, leaves her reeling and landing in the violent MC world where her natural instinct to run come out. One consecration the lack of memory fortified her—was to discover a thing she never gave a chance in the past—love.

When those who caused the hurt find out their target is alive, but under the fog of amnesia, they set out to finish the job. With her life in danger, the safest place is in Red's arms. He can heal the woman's body, but can Red convince her there's room in her heart for him?

THE CHRYSALIS SERIES

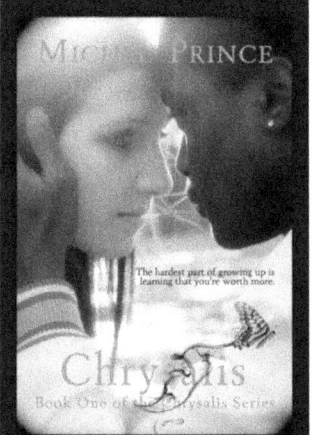

Bad choices are a Chisholm family trait, one that confounds the youngest child, Ellie, who's trying to separate herself by making smart decisions. And falling for Oscar Jeffreys, the hottest guy at school, would be number one on the list of Chisholm family disasters. Yet the crazy part is it's not a one sided attraction. Somehow Ellie has caught Oscar Jeffreys' eye. Sure she could see the barriers between them. Race, age, popularity. They were at opposite ends of the spectrum. But a demon set to destroy her family? She can't see that.

Oscar provides security and acceptance Ellie never imagined she deserved. As the passion of first love grows, Ellie honestly believes she has a chance to beat the odds and live a happy, normal life. Then her world collapses around her. With the help of a guardian angel, Ellie learns of a world that has unknowingly surrounded her for years. And she'll have to find strength buried deep inside to save not only her future, but flush out and stop the demon in her midst.

Ellie will have to learn that sometimes the hardest lesson about growing up is accepting that you're worth more.

When I was a child, I used to speak like a child, think like a child, reason like a child; when I became a man, I did away with childish things. ~ Corinthians 13:11

There comes a time in everyone's life when they must put aside their childish ways. In the past year, Ellie Chisholm has fallen into the security of her relationship with Oscar Jeffreys, emerging with a stronger sense of herself. But now Ellie's mother has started inserting herself into Ellie's life, treating her as if she were a child even though Ellie has begun to make very adult decisions for her future. Having finally consummated her relationship with Oscar, Ellie learns the powers inside of her stretch further than vaporizing demons.

Maria, the demon bent on revenge, has been reigned in by God but that doesn't stop her from disrupting and threatening those around Ellie and Oscar. Ellie becomes off balance as Maria switches strategy and attempts to destroy Ellie from the outside. Now the gauntlet has been thrown down. Ellie must help her family achieve positive change and finally break the tie between her mother and Gaap or risk losing everyone she loves.

Can Ellie maintain her sanity while walking the last steps as a child?

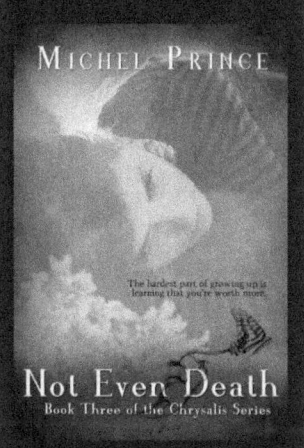

In one tragic moment, Ellie Jeffreys' perfect life ended and the devastation of losing the only man she believed she could ever love and their beautiful child causes the hopeless resignation that life shall never again be worth living. Bound by a decree from On High, the demons who tormented Ellie for years have had to leave the Jeffreys alone, but they grow restless, sensing Ellie's despair and vulnerability. They lust for her. And they're extremely resourceful.

Dr. Luke Page's inability to save Ellie's husband and son has him hoping to recover her crumbling mind and show her love does still exist in the world. Dr. Page feels immense pressure to be her security blanket in the concrete world, but thoroughly healing her presents a challenge that raises questions about his ability as both a physician and a human being. Ellie's depression now leaves her susceptible to the vengeful demons. In the past, the sheer strength of Oscar's love and devotion fortified a barrier around Ellie, shielding her from the effects of the world's iniquities.

Will Luke's love be enough to rise to the challenge of protecting her? Or will Oscar's become like a phoenix letting not even mortality stand its way?

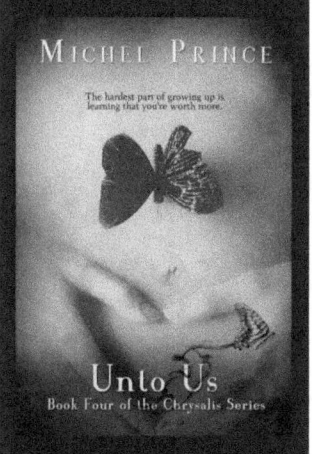

"No one ever said carrying demon spawn would be easy..."

Ellie Jeffreys is unsure of when or where she woke up, but one thing is certain—she's not alone. Having been violently ripped from her life, the return will be anything but smooth. Led back to the house and family she loves, Ellie soon learns an interloper will tie her to the enemy forever. Now unsure if the nightmare of Luke Page will consume her and finally allow Gaap to destroy the family she's created, she discovers the only way forward is to move on from the past and accept her place in an ancient prophecy.

THE FROZEN SERIES

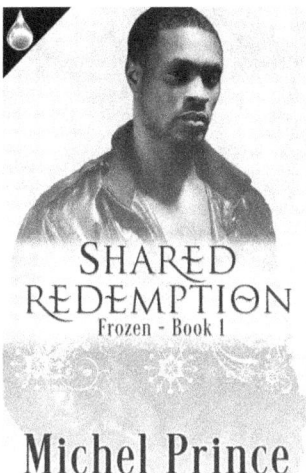

If your heart is frozen in time, can it still beat?

Seeking salvation, Nye is caught up in intrigue and danger that may end his quest for redemption and the life of the women he is destined to love.

Former slave Nye ended his life in 1859 after losing his love. The angel Gabriel has offered Nye a chance at redemption by hunting demons as a member of the Frozen. With less than seven years left until his salvation, Nye is staying on the straight and narrow – until a woman gets caught in the crossfire during a demon hunt.

After receiving devastating news, Kiriana Kladshon moves across the country, only to get caught up in the world of The Frozen. Nye and Kiriana are pulled into an attraction neither can control. Will it be their ultimate demise or their greatest salvation?

Damarion is leading a group of female demons on a mission. During his punishment on Earth, Damarion learns of dangers within his coven trying to stop him from returning to his love, still trapped in Hell and a love he was so sure was true...

Jimmy is young, handsome, and an effective distraction for Trisha, but he'll have to prove he's a man to protect her from a world she never knew existed. Redemption of Blood, Book 2 in Michel Prince's Frozen series will keep you turning the pages of this paranormal romantic suspense.

Trisha O'Driscoll started tending bar to give herself a flexible schedule and quick cash. She never thought the young soldier who wandered in with a fake ID would want a woman almost twenty years older. Although she draws the line at commitment with him, Trisha can't help falling for this mysterious stranger and his dark past.

James Schmitt took his life to escape his pain. The offer from the angel Gabriel of working toward salvation gave him a chance to take responsibility for his actions, but his inner demons won't stop tormenting him. Gabriel gave but one order—protect Kiriana, James' partner, at any cost. And he'll be damned if he lets anyone down ever again.

Princess LaDressa, daughter of Lucifer, has come to Earth for revenge on the woman who slew her beloved Damarion. Kiriana holds his ashes, and with them, his only chance for resurrection. One way or another, LaDressa will be reunited with her love.

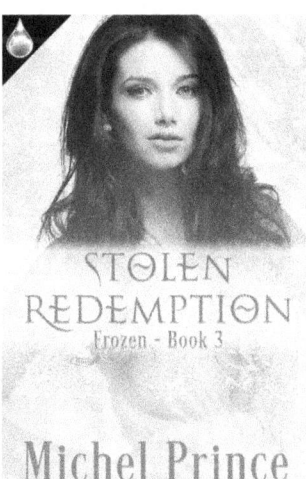

Esther, Vincent, and Pivane thought they knew what side they were on.

When Esther Benson became Frozen, she thought she'd spend the rest of her afterlife searching for salvation. She never thought she'd find it in the arms of a small town detective.

Detective Vincent DeTello thought a small town would be just the place to bury his past. Mount Pleasant, Iowa, is a sweet town on paper, the kind of town where a guy could forget his feelings and live to serve and protect. He didn't count on meeting Esther and having the gates of his heart forced open again.

With all his rivals captured or injured, Pivane is poised to finally become leader of his demon clan and make all his dreams come true. However, even his black heart can be touched by love. A love he'd have to throw away everything for.

They thought they knew whose team they were on, but love changes everything.

GROWING STRONG SERIES

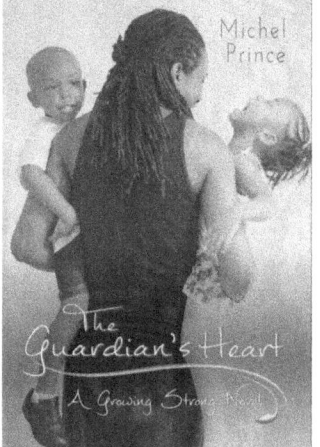

Case Thomas is always in control whether it's on the basketball court, the lab where he works, or in his love life. He thinks he has everything all figured out. All that changes when his parents pass away during his last year of college and Case is thrown into fatherhood when he becomes temporary guardian to two adorable twin toddlers. Weeks later, exhausted and running out of time, Case must decide if he's ready to become a father to these children, or give them up and move on with what's left of his life. Then he meets Gabbie Vaulst.

Gabbie is amazing with the kids, owns her own business, and has all the right curves in all the right places. She can tell Case is attracted to her, but does he really love her or is he just settling for a surrogate Mom who can wrangle his new kids? Knowing that she's falling in love with him, she chooses to push him away until his world straightens out. Can Case prove to Gabbie, and himself, that his feelings are real? Or, is this sudden family too much for both of them to handle?

The odds, as well as members of their past who've come out of the woodwork, are against them, but when kids are involved, all bets are off.

At the tender age of seventeen, Mary Beth discovered the family she thought would see her through anything couldn't accept her one mistake. Thank goodness for her best friends that stepped up to support her decision to keep her child. Seven years later together with her friends, she's created a successful business on the verge of a large expansion.

But the desire to be accepted by her family continues to be a failure that taints all her accomplishments and has her making concessions she never thought she would.

Elias Marquez was content with his life. He definitely wasn't looking for the vibrant redhead down the hall from him. After a chance encounter, he can't escape the need to be in her company again. He wants to explore the possibilities and the undeniable spark her touch inspires.

Torn between trying to right the past and accepting that she can only control her own life is Mary Beth truly ready for the love Elias is prepared to offer as a future?

Karen Schroeder made the choice to be a politician. Her local success has caught the eyes of her party and she's suddenly thrust into the national stage. She knows how to play the game and exactly who she needs to be, even if it's not who she really is.

Sarah Lindstrom has never questioned her feelings, even when they made her believe her girlfriend would say yes to her proposal instead of breaking up with her. When she sees Karen Schroeder campaigning, the rush of attraction is undeniable. Sarah knows she's been wrong before, but her feelings for Karen overwhelm any apprehension for this woman who's trapped in the closet.

As the relationship grows, Sarah learns love can be painful when the one you love can only be herself when the door is closed. More importantly, her love of Karen could cost her everything she's worked for. Can love bloom when hidden in the dark?

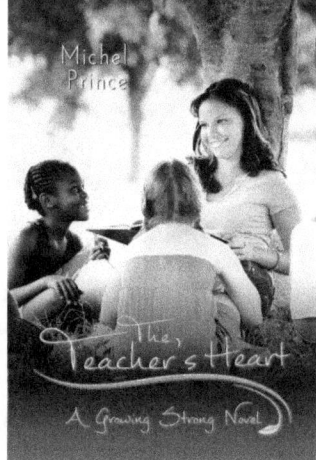

There's no way Mandy Butler would ever let herself get attached to anyone. Sure, sex is fun, but love is for suckers. Her parents taught her that. She has her friends, a job she loves, and lots of fun flings. Everything she thinks she wants.

Ashton Gilmore is at a crossroads when he meets Mandy. She's every thing he's ever wanted in a real relationship, but she might have too much baggage for even this hot political fixer handle.

For the past few years the women of Growing Strong Montessori have been discovering loves they'd never thought possible. Sans one, Mandy who has spent the last few years taking one hit after another and can't see Ashton Gilmore as anything more than a bump in the road.

Ashton has to find a way to teach Mandy that love exists, before she gives up on the concept all together.

THE LONG RANCH SERIES

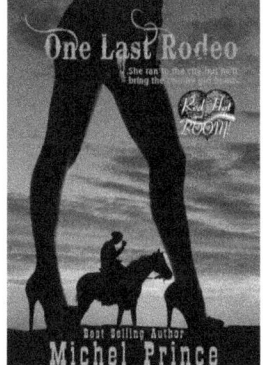

Betsy Flynn's star is rising as she serves as the color sports reporter for the local CBS affiliate. Her focus, knowledge and high heels have become a staple along every sideline in Minneapolis, but a rodeo has come to Minnesota and this Texas transplant will have to go back to her roots

Five years ago pick-up man JT Long chose his best friend's rodeo career over the love of his life, Betsy.. As JT's rodeo shows up in Northern Minnesota he quickly realizes his chances of winning Betsy back are getting slim as he learns he only has one last rodeo to win her heart.

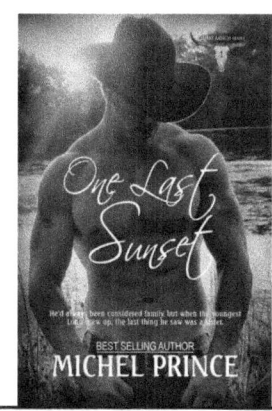

Sunshine Parker didn't walk away from Tender Root, he ran. Joining the rodeo let his body be beaten by broncos for money, instead of his father for free. After an injury forces him to return to his hometown, he heads to the Long Ranch, the one place that's always accepted him.

Melody Long is Long Ranch's first cowgirl in a hundred years. With brothers and cousins always looming in the background, Melody had given up on dating long ago. Now back from college, she uncovers something even the Long name can't protect her from.

Men who want to survive keep Melody at arms length. But Melody isn't the bookworm Sunshine remembers growing up, and it's hard to hide his new found lust. Will his desire cost him the only place he's ever considered home?

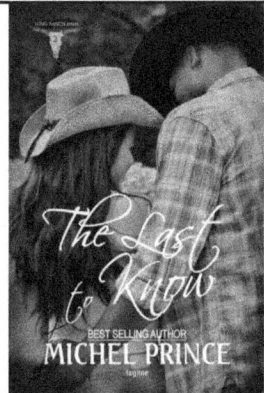

Savannah Georgio stopped wondering about who her father was before she turned eight. Her mother made it clear she would never tell. So, why worry about someone who would never be there? Only someone did know about her and soon, she was on her way to Tender Root, New Mexico to inherit land from a man she never knew.

Clayton Long was raised with the belief he would one day not only work, but own the Long Ranch. As he got older, he saw he wasn't the heir, but the spare to the ranch as his older brothers and cousins blocked him from major decisions. When the Winston Bastard showed up in town, his brother taps him for a special project to save the ranch. Only Clayton gets distracted because when he looks at Savannah, he sees a future with the girl trying to discover who she is.

As secrets get revealed and family members question the validity of Savannah's claim, she can only count on one man from the neighboring ranch, but is he too, keeping a secret that will have her running from her new family?

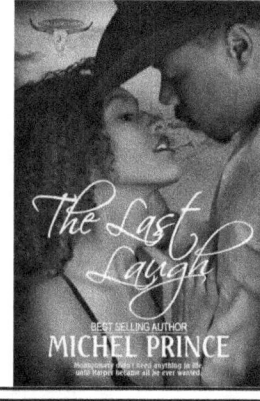

In Tender Root Montgomery Long seemed singularly focused on fun. The middle child he only had one real duty, taking care of his younger sister Melody. But he'd failed and as the months tick on without her attacker behind bars he's itching to exact revenge on the man who almost took his baby sister's life.

Harper Maxwell's year had gone from bad, to worse. With an ex husband looming around making her life miserable, the chance to get away to Mexico for a case made sense. As the attorney assigned to the Long case she was set to serve extradition paperwork and hopefully catch a few rays at the beach before heading back home.

If only that could have happened, with threats on Harper's life can she find safety or even love in the arms of a man who never commits and worse yet may only be a rebound? Or will she become the next tragedy that could destroy the Long Ranch?

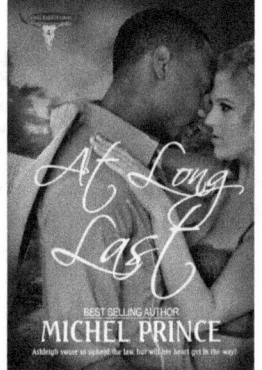

When gunshots echoed outside the courthouse in Las Cruces, New Mexico, Miles Long took off in a blind rage of protection. Two men were dead and Miles and his family were the ones in handcuffs. Quiet and reserved, the bookworm cowboy has to keep from being locked up and save the ranch his family worked for over a century.

Ashleigh Wood had one job, help Hamilton Boyle convict three members of the Long family for murder. Being against her best friend's new family and tasked with researching the history of the Longs, she soon discovers she's falling in love the man whose bullet matches the fatal shot.

Can Ashleigh set aside the desire drawing her to a man she knows is capable of murder? Will justice finally come to the Longs' of Tender Root, or will the final straw destroy what their family has struggled to build?

LOVE BY THE YARD SERIES

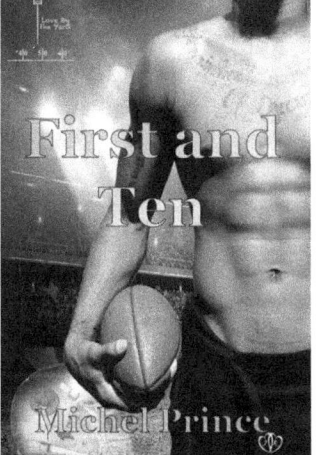

In Chicago they say Speed Kills, or at least they have for the last seven years since the handsome running back, Jerome Speed, led the Chicago Grizzlies to divisional and conference championships.

Danika Albright's privileged upbringing has most people believing she wants for nothing. As the daughter of a self-made billionaire she shouldn't, but her father never wanted his children to be spoiled and demanded they make their own way with little to no help from him. While working her way through school as a stylist, she crosses paths with a local football star with his own issues.

The pair work to keep their desires from molding their relationship, but when a paternity case tackles the star and the woman wants more than money, the relationship takes a hit.

Can Danika and Jerome look past what they know and take the time to discover what really happens when you fall in love with a person—one who wants you and not just your name?

Two people—two different backgrounds—one goal—to learn to love one yard at a time.

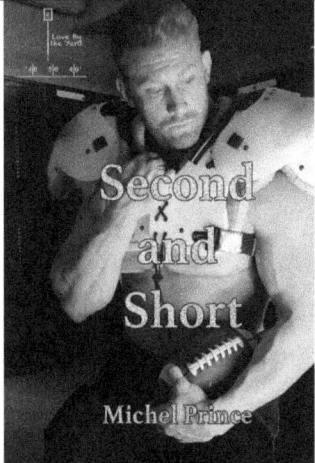

Offensive linemen are considered the silent protectors of the game. Always expected to be there, but never seen by the fans. Whether by accident or circumstance, Dalton Gresham has been known as the Blood Thirsty Bear of the Gridiron since his rookie year. With fans wearing number seventy-seven with fake blood dripped on it, can this giant in football shake his monster status?

Having hidden away at Lost Lake, Wisconsin, the last thing Willeen Fire needed was publicity. The tall, voluptuous woman has a beauty she hides behind flannel shirts and engine grease while staying off the grid. When Dalton first meets Willeen, the last thing he thought was she was a woman in need of protection. But as he falls for her, the natural instinct to protect is screaming in his ears.

Can Dalton stop being the monster he's been labeled and become the one who will finally save

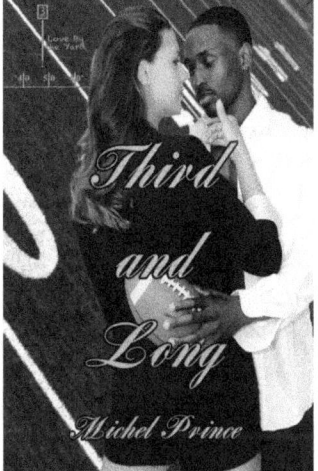

Ten years ago, Coach Xavier Jackson was poised to complete a lifelong journey. When he wasn't picked up after the seventh round of the draft was over, he was left to wonder if his dreams of playing professional football were finally over. Instead, with a chance as a free agent he made good on his, but the lure of off-field activities led the tight end to make the worst decision of his life.

Chelsea Monroe was engaged to the best football player their little college had ever seen. She'd become part of his family, tasked with keeping his baby sister, Leeda, safe when he had to go away. But a visit between training put an end to everything, leaving her shattered and unwilling to give herself to anyone ever again.

Though a decade of focus on her career made her a sought after litigator, it kept her from making any personal connections. Chelsea decides to take a trip to Jamaica before her fresh start in Chicago, but instead of it being a break, it turns into a second chance.

Leeda Jackson has plans for her brother and the woman that should have been her sister.

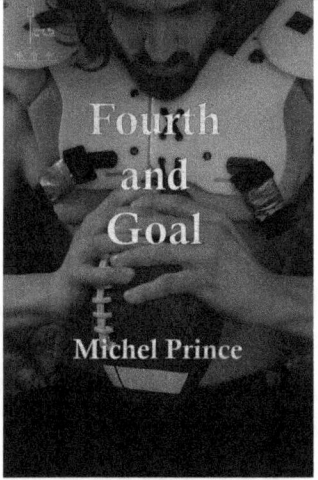

Beaumont Guthry, in his short time in the sport, prepares to step out of the shadow as a backup quarterback and into the spotlight as he takes over the Chicago Grizzlies. The team may be desperate for a quarterback, but Beau fears his style might get him benched before the first pass is in the air. For Beau, it will be the first time his father's money won't help to smooth over any missteps he makes.

The thirst for knowledge is what has kept Esme Carmichael in college for the last eight years. When her parents draw a line in the sand, forcing her to pick a degree and graduate, Esme realizes her biggest worry in the last decade has been could she swing more than two hours sleep a night.

Esme, instead of the four walls and security of a classroom, is faced with the future, one which petrifies her.

Meeting Beau seemed to be the perfect distraction she needed. What she didn't count on was his past derailing their chance for a relationship—a relationship, she nor he signed up for. It was

MORE GREAT BOOKS BY MICHEL PRINCE

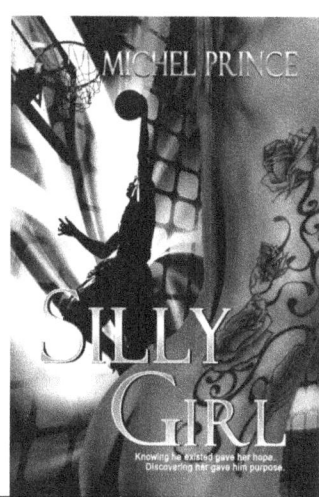

Are professional sports just children's games played by oversized kids? With an all-consuming focus Matthias Jessup has sacrificed his body in pursuit of greatness. But while he's enjoyed the spoils of being an elite athlete, the physical punishment can only be held at bay for so long. He knows his time is running out and he will have to face his future soon.

Sylvia Kinder is obsessed with Matthias' public image. But now that her fantasy has walked into her life, could it possibly lead to a happy ending? She worries if there's any place for her in his world, much less his heart. Drawn to each other on a chance meeting, Matthias must look off the court and discover the real world, while Sylvia will have to find the strength of self to not become lost in a world she doesn't understand. But those who aren't ready for a life after the game surround Matthias and are willing to do anything to keep him on the court.

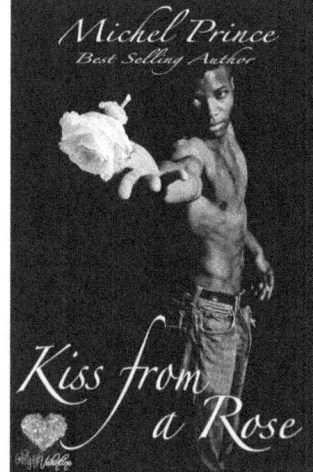

Jenna Turner wasn't looking for anything but a quick bite to eat when she met the sexy peace officer Marcus Peterson. While Jenna has always been singularly focused on her next big promotion at work, suddenly she's distracted by alluring texts from Marcus.

His evocative words and her naughty responses invoke emotions neither seem ready for, and luckily, neither have room in their busy lives to follow through on all their sexting.

Can two career driven people find the time to take their relationship to the next level? Or will careers and the pressure to achieve goals cause the end to a budding love?

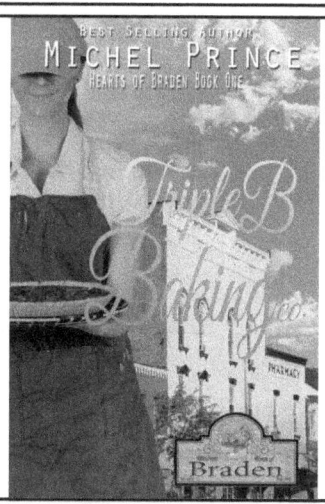

Three years ago a heart broken Merryn Sota got in a SUV and drove away from California. Call it fate or serendipity, but when the vehicle broke down outside of Braden, Iowa she fell in love with the calm and community. Using her skill as a baker she opened up Braden Buttery Bites Bakery which the town lovingly renamed the Triple B. Every confection she makes heals her wounded heart a little bit.

Ever since the tragedy, the only way Austin Larsen can cope with life is to have it completely regimented. The Triple B brought schedule to his life. Something to focus on day by day.

When a snowstorm hits the small town Austin's schedule is disrupted and old wounds are reopened. Only the hospitality of the Triple B, along with Merryn, can right his world. However, as Merryn and Austin grow closer, their pasts resurface and threaten to destroy their happiness forever.

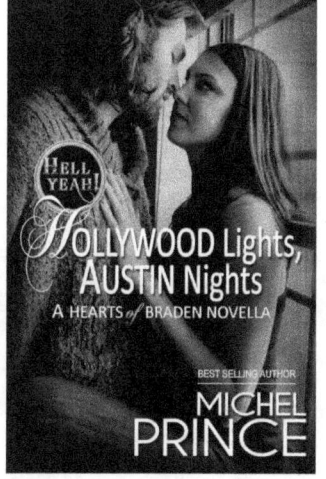

Soren Birch wrote a movie deserving of the best Hollywood has to offer, but as a first time screenwriter, he's stuck on a shoestring budget. Vision Star has offered him a deal and set him up in Austin, Texas with Zane Saucier as a local contact. Now the actor turned writer will be donning a few hats, including director, as his passion piece comes to life.

In Hollywood, Alicia Winters' star is rising, but she is slowly learning quantity over quality after being kicked off her latest set. She then finds her way to her sister's bakery in Braden, Iowa. A few days of rest and little tough love has her ready to take a chance on a small budget film in Austin.

A dream actress and a company willing to take a chance on him, Soren is beginning to think he might actually make a name for himself beyond being a sex symbol. Can his luck finally be changing or will his attraction to Alicia derail his dream before it even starts?

MORE GREAT BOOKS BY MICHEL PRINCE

Barton Nuril has attended the Harvester's Gala for more years than most. He'd given up the dream that a woman would want him for more than copulation until a dark haired beauty he dubs Fire fights to get him in bed. Even as those from his province plot to take down the establishment and all its traditions, Barton for once, is discovering love may exist.

Abigail Stone knew the Rules chapter and verse. Even as others perverted their purpose, Abby stayed true and attended the Harvester's Gala to find her soul mate. Just as she feels she's found him the fates step in between omens and a battle no one could have foretold Abby is sure her choice is doomed. Will she see beyond her traditions and still stay within the rules to find love?

Can love ignite when one believes it no longer exists and the other fears the fates have doomed the union?

A contemporary retelling of the Wild Swans

Once upon a time, Elsa Swanson lived a charmed life, tucked away with her six brothers. When her father remarries, the children are thrilled to meet their stepmother. That is until they discover witches do exist in the world. A curse took her brothers from her and she must knit nettles into sweaters without making a sound until all are complete.

Duke King is a med student with an empire being handed to him. When his father chooses to extend their property to an untouched forest, they discover a woman living alone who only communicates with her eyes and gentle touches. The aspiring doctor first sees a patient, but as each day passes, he falls in love with the determined woman.

Elsa had forgotten the touch of another and had never known the feel of a man. So close to saving her brothers, the witch has returned now and is using manipulation to make Duke question Elsa's sanity. Can Elsa stay true to her brothers or will her growing desires to know Duke cause her to break her vows?

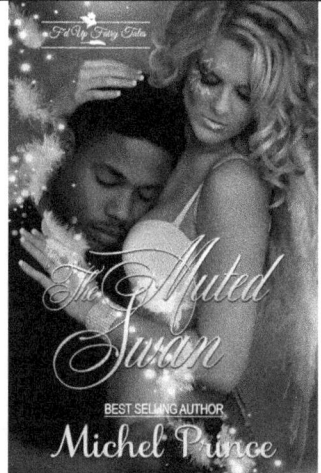

Sterling and Elizabeth Jackson have built a life most would envy. A beautiful home, two wonderful children and a very comfortable lifestyle. Yet something is tearing them apart. With divorce looming, they are trying to make it through the holiday season for their family.

With clashing schedules, demands from employers and two busy kids, the former lovers have managed to stay out of each other's orbit, at least for a while. But Fate, or maybe their well-meaning family, has set them up on a collision course.

Past memories bubble up to the surface and there's nothing to stem the flow. What once was amazing has turned hurtful and full of pain. But is that the real story? Is it too late for a couple who once lived and breathed for each other to find their way back?

There's a thin line between love and hate. Will Sterling and Elizabeth be able to mend a love that seems broken and lost, or will the final pull on the holiday ribbon unwrap their last chance to save their marriage.

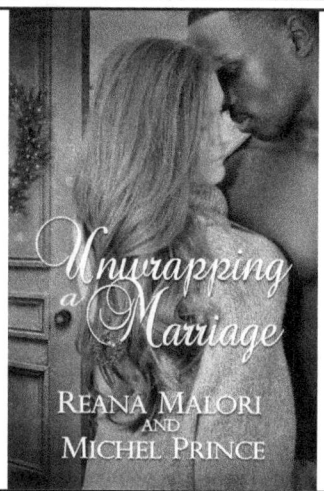

Kelsi Stamp is known all over the world as a best-selling science-fiction author. Living in a small town, she's able to stay hidden, tucked away in her cabin in the woods. Outside of her internet searches, she stays away from the world. Readers are fickle and love has turned to unhealthy obsession in the past.

As a blizzard bears down on Northern Minnesota, Kelsi's lights flicker, then go out right after a large crash echoes through the wilderness. A truck holds an unconscious stranger she is being pulled to, but who is Jace Runyon and why was he driving so fast on a road no GPS even knows exists?

www.ingramcontent.com/pod-product-compliance
Lightning Source LLC
Chambersburg PA
CBHW080946170526

45158CB00008B/2391